Rum & Porn
By
Branson M. Smith

This book is dedicated to my family and supporters, who have believed in me over the years ...

Rum & Porn

'The Mirror Dawning'

The mirror offers no relief
The clock keeps ticking with each breath
The wrinkled face wrinkled in time
Heading towards an inevitable death

Bleeding, feeding, and turning blue
Who are we? What to do?
He created us for some odd reason
Like a leaf out of season

Bittersweet, we enjoy the fruit
Fractured time without a root
I hurt by knowing I'm with time
Following, marching in its line

Play the key to the melody
For the song ends eventually
I sing my words and hurt the most
Death is knocking and I am his host

Feeling cold, I lay and wait
Waiting for my final date
He whispers in my open ear
Never ever be afraid, my dear

He holds me close as I shut my eyes
He's no villain to my surprise
The taker of souls holds me now
As I take my final bow

Dreaming it behyt

'Dreaming Abstract'

All the colors fade
In time, they run

All my memories faded
All my thoughts jaded

When I recall another time
Things aren't what they seem
The worm on the hook. Another dust on the breeze.
Meaningless and thoughtless again.

Everything culminates
To this very moment

When I recall another time
Things aren't what they seem
The worm on the hook. Another dust on the breeze.
Meaningless and thoughtless again.

'Thy Sullen Promise'

You never watched as I burned.
At the stake, then you learned.
I wanted to be something more than this
But it fades into the abyss.

Venture… into the unknown.
Go on… into the unknown.
I promise you I'm not the one…
The one who started it all.

The stench of the witch lingers in my brain
The incandescent light… the frustrating pain.
All is left behind. Left for tomorrow.
I reach to you, but only feel sorrow.

Venture… into the unknown.
Go on… into the unknown.
I promise you I'm not the one…
The one who started it all.

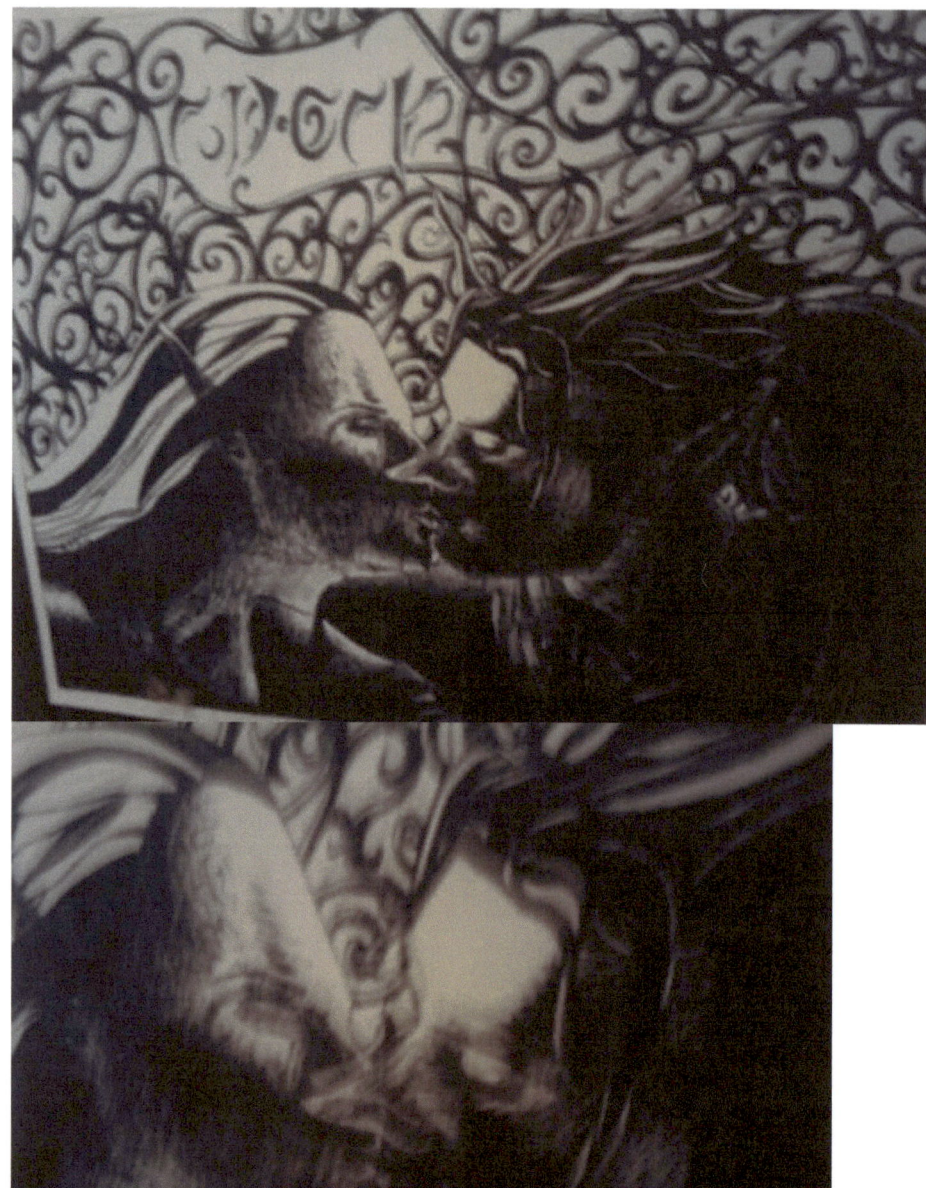

'Dehumanizer'

What does it take?
Who are you?
Bring to me everything…
And I'll bury your sorrow.

Deactivate me.
Confuse me.
I don't know where to go…
Confiscate me.
Betray me.
I don't know who you are...

What does it appear to be…
When all your thoughts collide?
When does it fall apart?
Only along for the ride.

Deactivate me.
Confuse me.
I don't know where to go…
Confiscate me.
Betray me.
I don't know who you are...

'Legacy of the Blade'

Born by the guillotine
Legacy of the blade
Cursed by the saw
Everything fades.

Legacy… Of the blade…
Never knowing who you hurt.
Cursed by your father…
Killing mother earth...

Dawn of tomorrow.
Volunteer your right.
Dead by sorrow.
Yesterday dies.

Legacy… Of the blade…
Never knowing who you hurt.
Cursed by your father…
Killing mother earth...

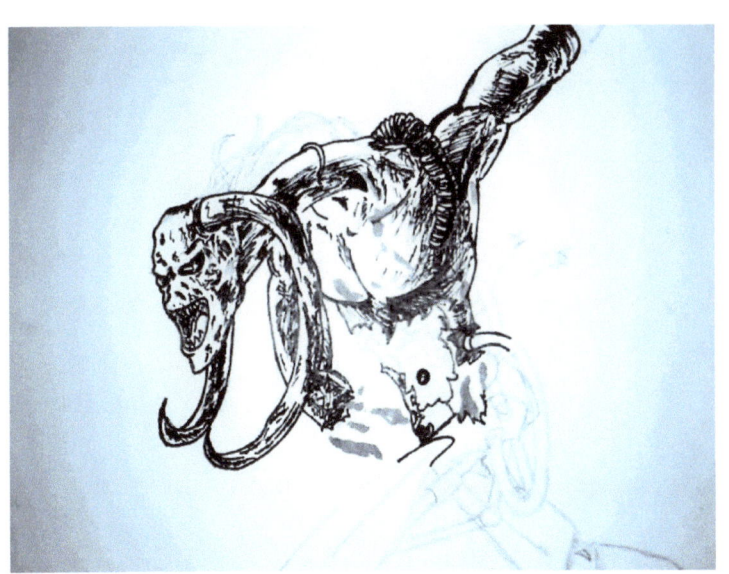

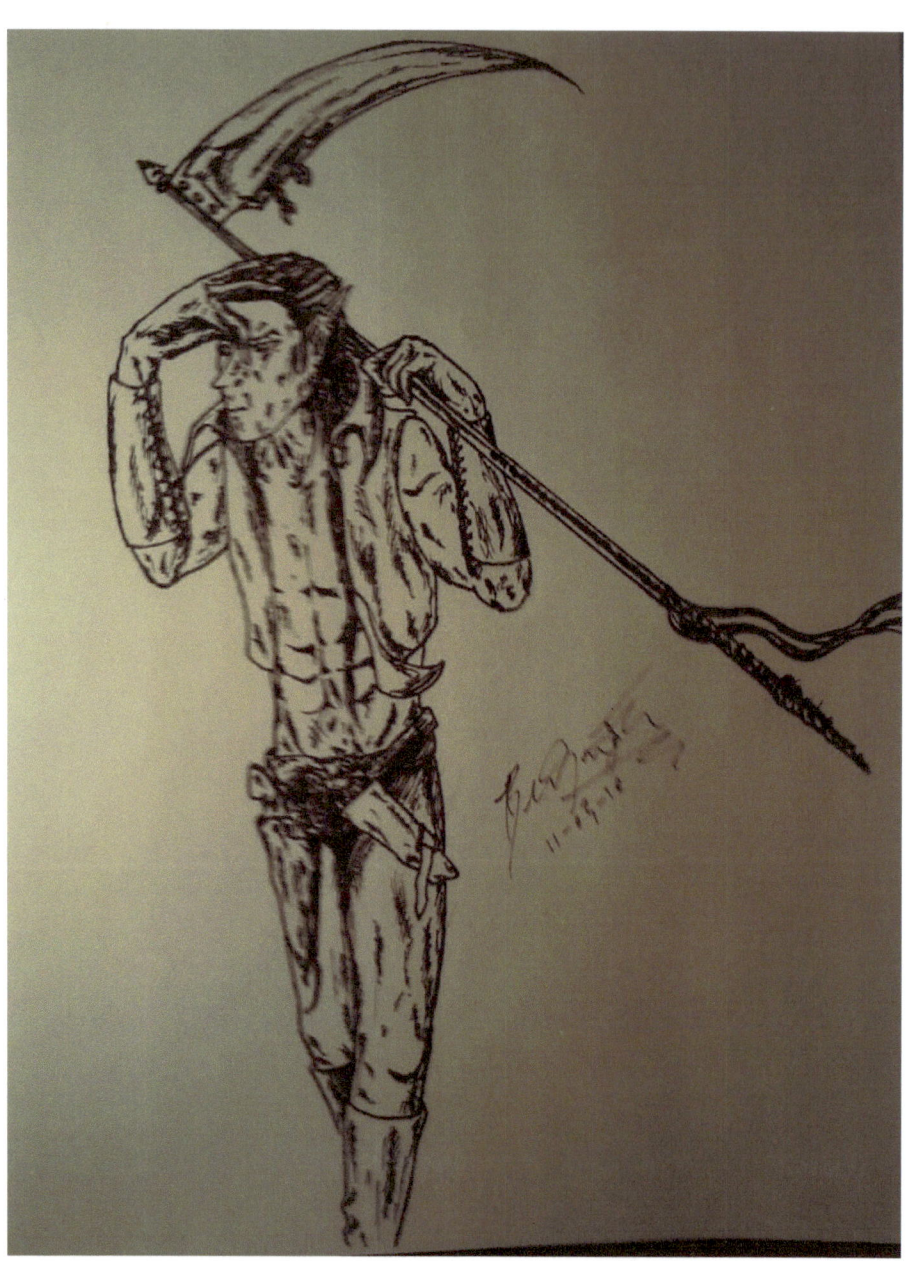

'Father & Mother'

I look into your eyes and I see nothing
I look to the East and I see nothing…
Buried with time, we salvage…
What we can.
I wander the plains and feel nothing.
I wonder about the Earth and feel nothing…
But I know… You are the one…
To succeed.

Conform is to die on the altar.
Where have you gone, my father?
Desecrate and release me from my shell.
Illuminate and be as one.

I feel it's only growing colder.
For tomorrow is without a mother.
Where do we go? What do I do?
Only the strong survive.

Conform is to die on the altar.
Where have you gone, my father?
Desecrate and release me from my shell.
Illuminate and be as one.

Ask and you will see.
Burn and breathe.

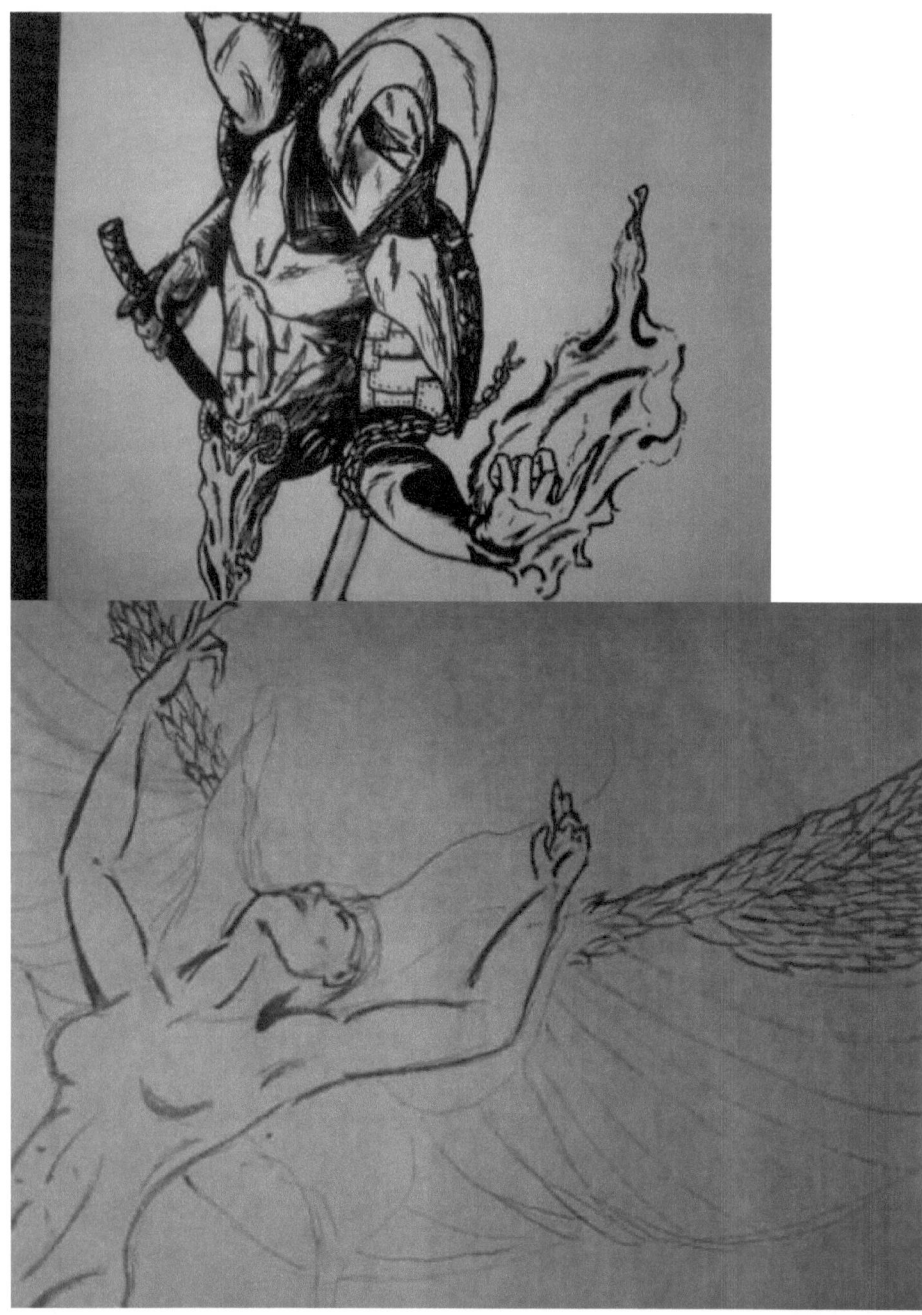

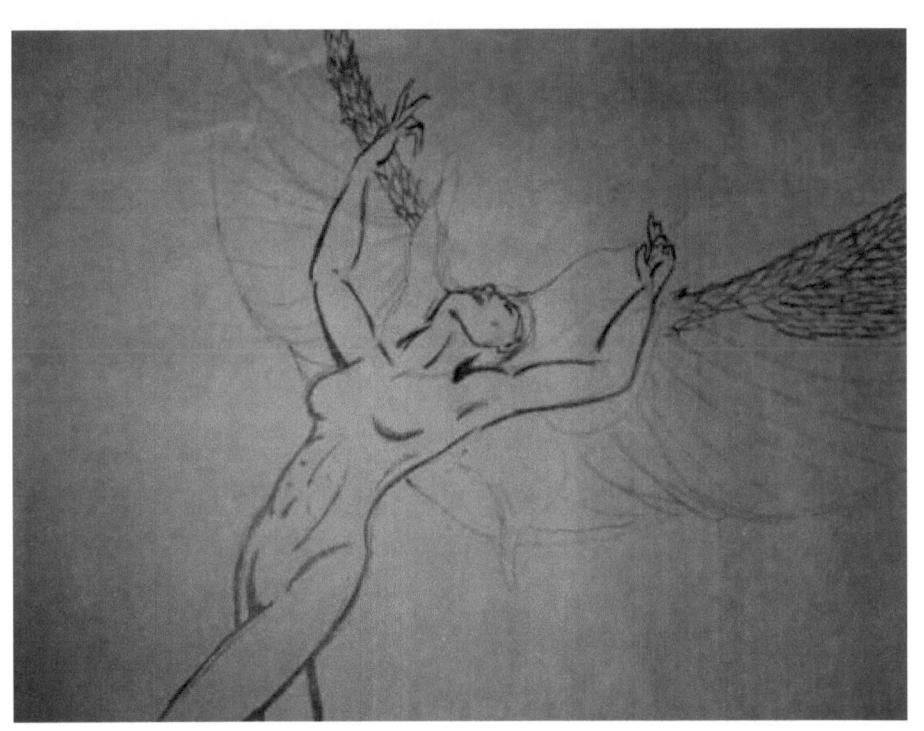

'The Gauntlet'

Refuse your maker
Burn in the light…
Tear away my eyes
Suffered until you die…
Fight the good fight
Never let go…
Curse this arena
Never will I show…

My burning! Hearts on fire…
This hurting… the prince, the liar.
I can't stop to think and say…
Live for tomorrow: a better day

Fight the Hellion
Turn away…
Never going down…
Never slowing down..

My burning! Hearts on fire…
This hurting… the prince, the liar.
I can't stop to think and say…
Live for tomorrow: a better day

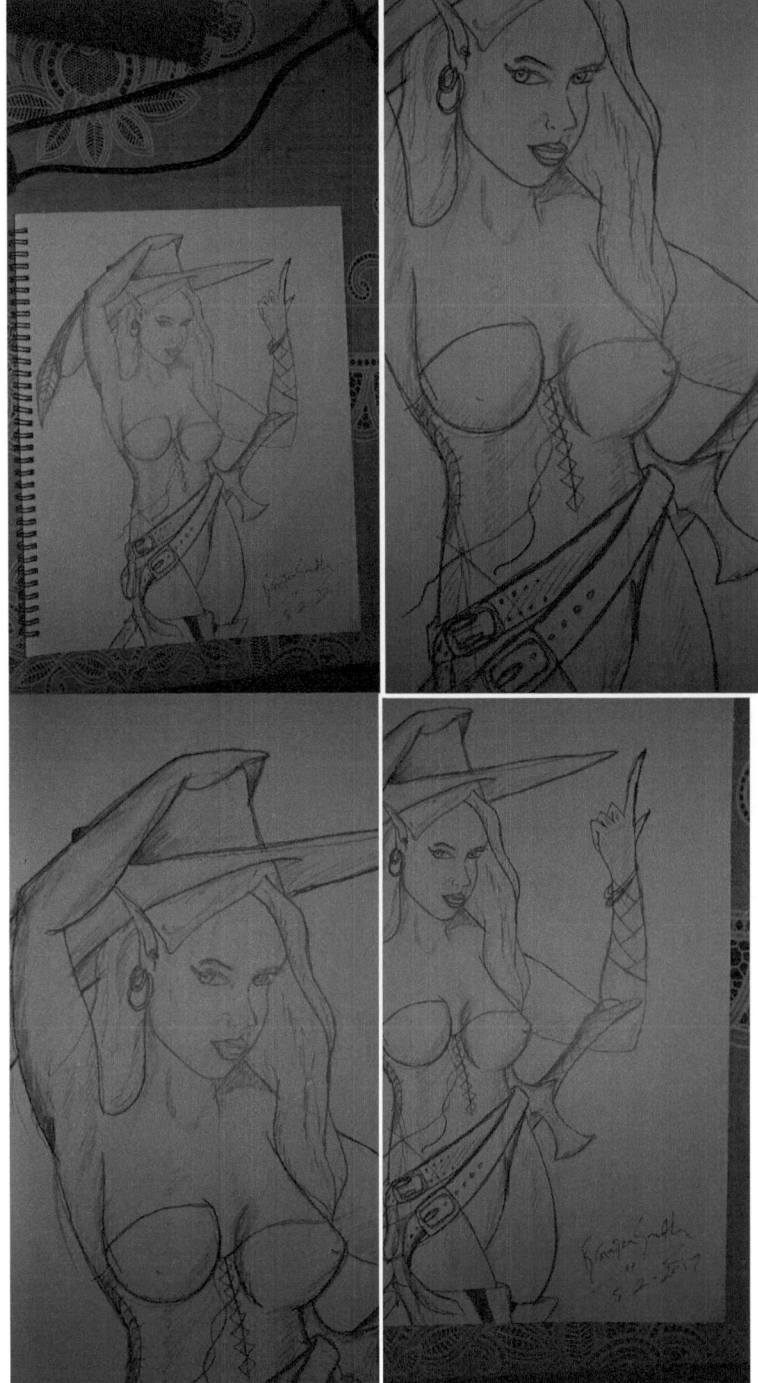

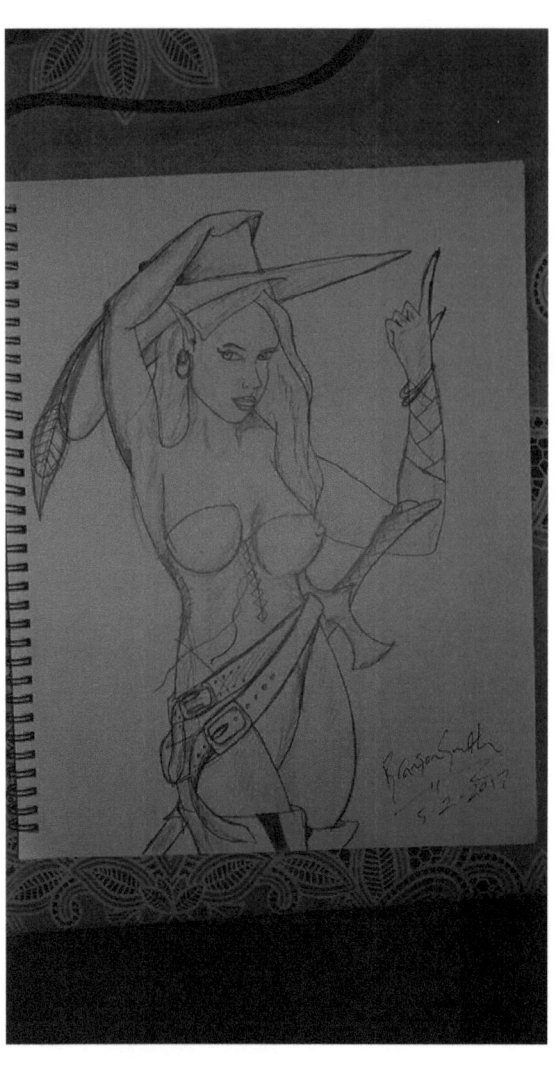

'Crucifier'

The storm comes crashing down
The fire's lit on the cross
Another day breaks the horizon
And another night ends in tears

And all we see is the past
Never knowing tomorrow
And all we hear is the word
The unspoken words of truth

The flames lick their flesh
Another burning at the stake
Treason and malice bring in the dawn
Dust at dusk make for bitter dreams

And all we see is the past
Never knowing tomorrow
And all we hear is the word
The unspoken words of truth

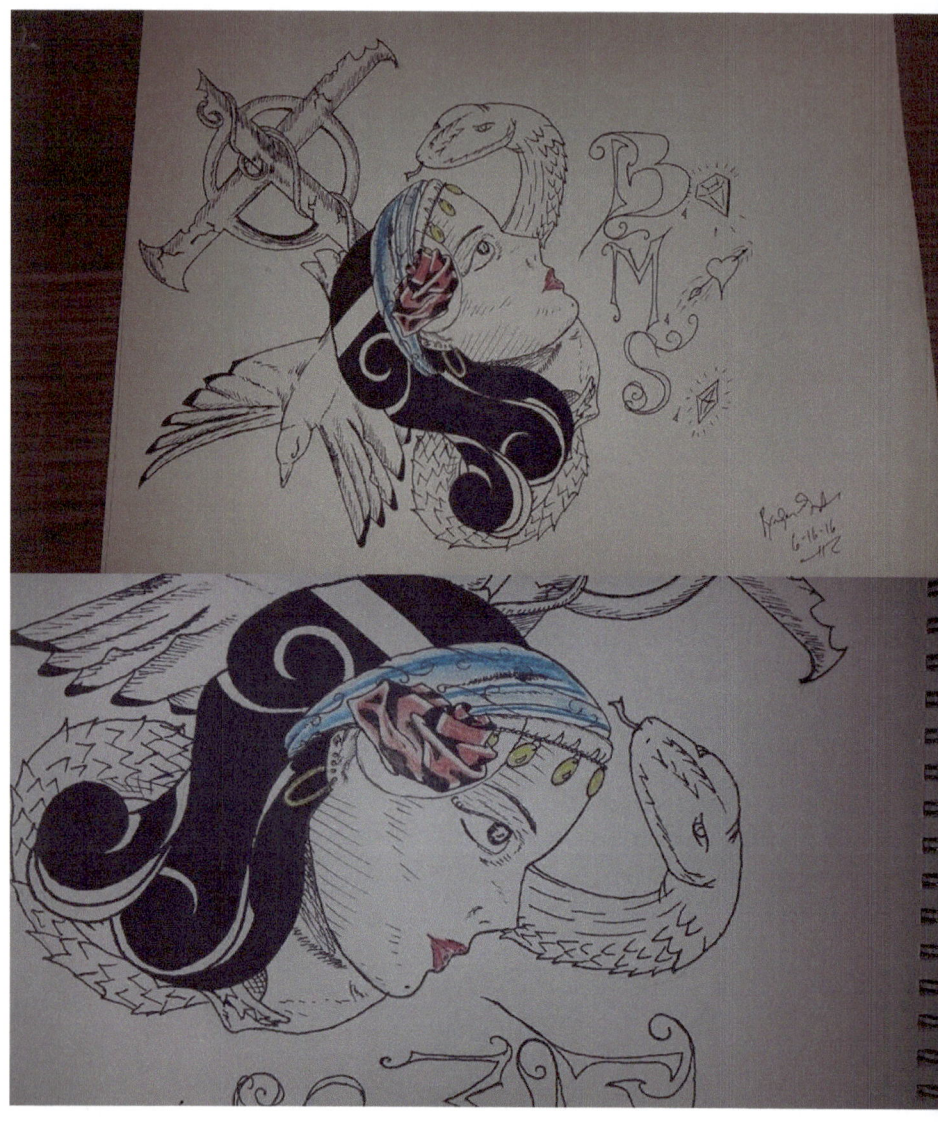

'The Alchemist's Apprentice'

Follow me now…
Into a world of madness.
Follow your soul…
Drive away the sadness.
Fear nothing. Die for no-one.
Magic comes alive…
Blend the earth. Deliver your heart.
The sullen are alive…

Worship nothing and believe in everything.
I'm here to teach you the way of the world.
No one can help you from knowing the truth.
Only I can show you what you can do.

Follow me now…
Into a world of the extreme.
Follow your soul…
Nothing's what it seems...

Worship nothing and believe in everything.
I'm here to teach you the way of the world.
No one can help you from knowing the truth.
Only I can show you what you can do.

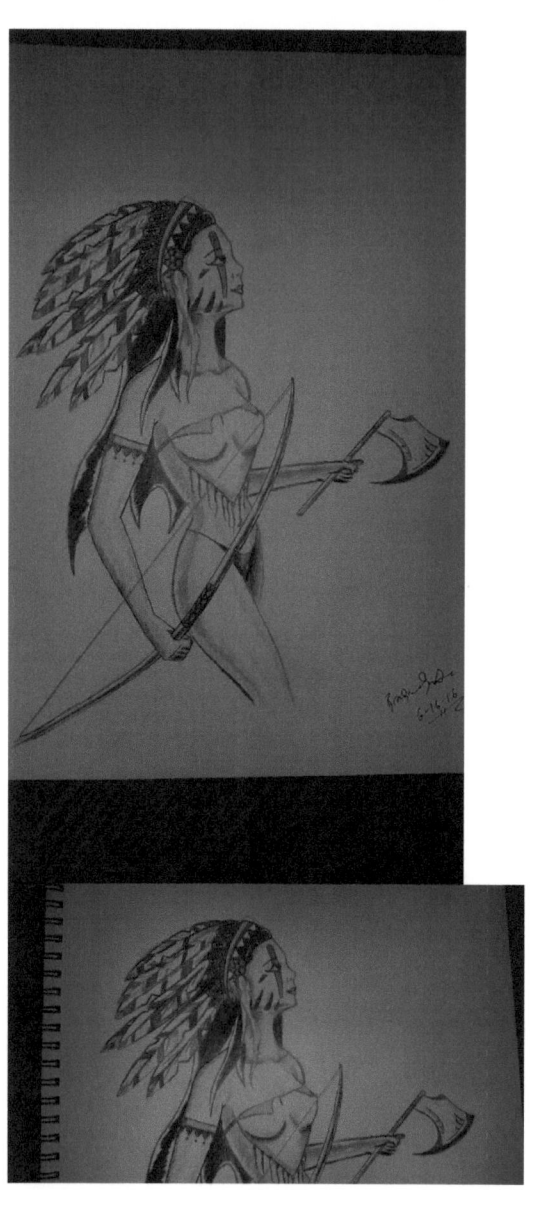

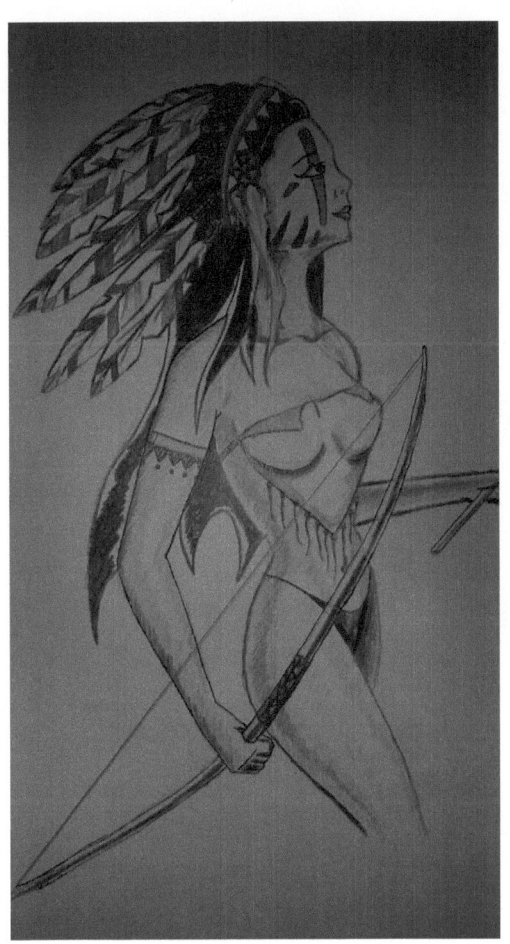

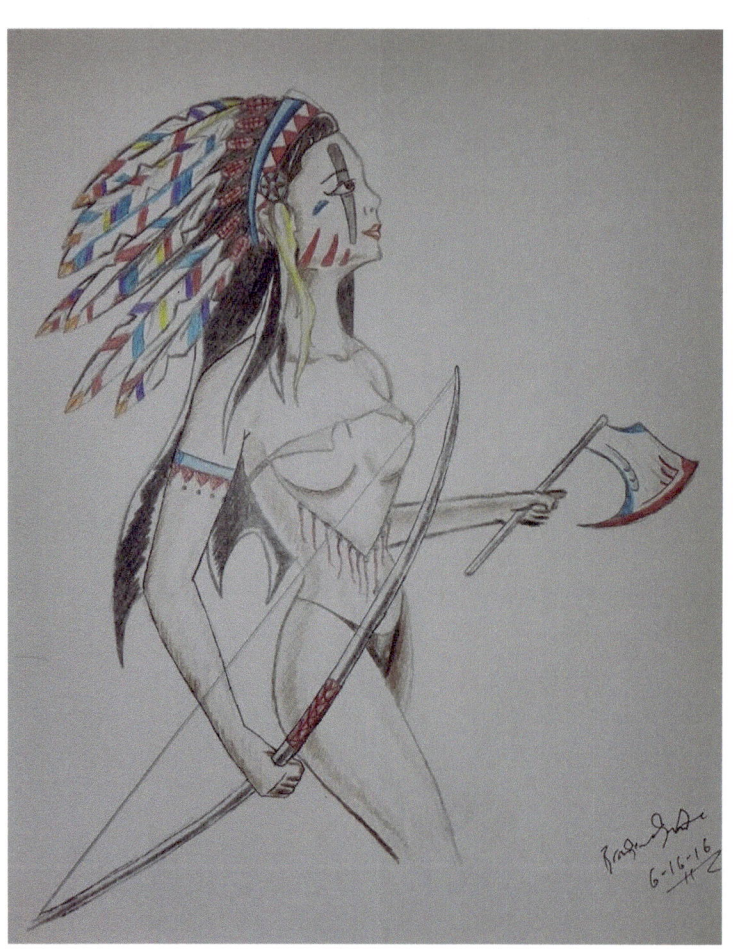

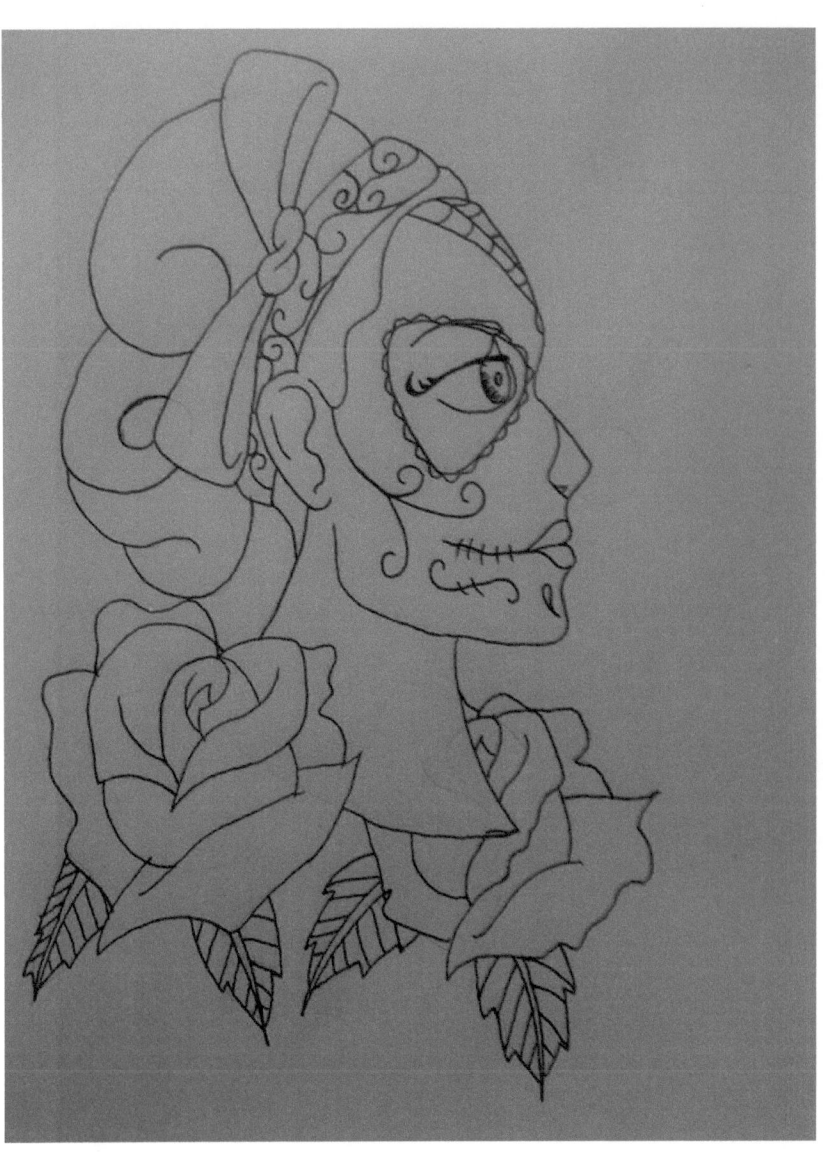

The End

www.ingramcontent.com/pod-product-compliance
Lightning Source LLC
Chambersburg PA
CBHW041117180526
45172CB00001B/290